Happy Mother's Day
Donna!

I love you so much
and I'm so proud of
all you've accomplished

♥ Mom
May, 2000

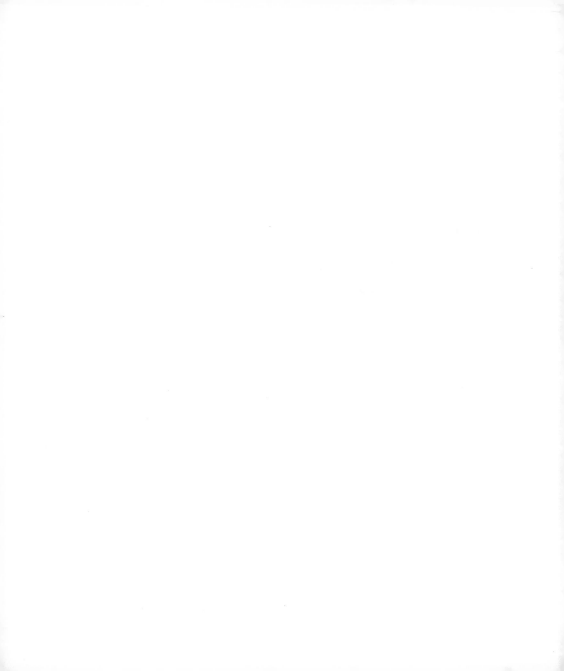

Words

FOR MOTHERS TO LIVE BY

A HAPPY FAMILY

HEAVEN IS ON EARTH

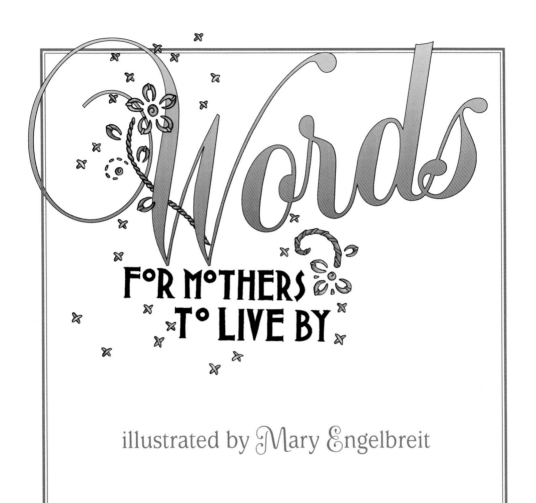

Words

FOR MOTHERS TO LIVE BY

illustrated by Mary Engelbreit

**Andrews McMeel
Publishing**

Kansas City

www.andrewsmcmeel.com
www.maryengelbreit.com

 is a registered trademark of Mary Engelbreit Enterprises, Inc.

Words for mothers to live by / illustrated by Mary Engelbreit.
 p. cm.
 ISBN 0-7407-0685-3
 1. Mothers--Quotations. 2. Mothers--Quotations, maxims, etc. I. Engelbreit, Mary.
 PN6084.M6 W67 2000
 306.874'3--dc21

 99-057367
 CIP

Illustrations by Mary Engelbreit
Design by Stephanie R. Farley

ATTENTION: SCHOOLS AND BUSINESSES
Andrews McMeel books are available at quantity discounts with bulk purchase for educational, business, or sales promotional use. For information, please write to: Special Sales Department, Andrews McMeel Publishing, 4520 Main Street, Kansas City, Missouri 64111.

Contents

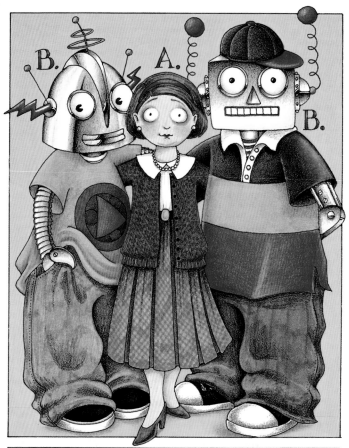

A. THE MOTHER B. ALIEN TEENAGERS

THIS TOO SHALL PASS

A few Words...
from
Mary Engelbreit

I can honestly say that if I weren't a mother, I wouldn't be where I am today. (And because I *am* a mother, where I am today is probably sitting home worrying whether my two teenage sons are safe and behaving in a way that wouldn't make me wince.)

I was an artist before the birth of my first son, but you surely didn't know me then. In those early years I tried on artistic styles and I cast about for appropriate subjects. Mostly, the characters that populated my work were mythical creatures, dragons, fairies, gypsies and unicorns . . . fun to draw, but not *real*.

And then I became a mother, and life got real, *real fast*. Motherhood changed my world. Suddenly I was surrounded by scenes and subjects that seemed to matter *more*. The events of my day-to-day life were so much more compelling to me than unicorns and castles. In my art, I traded in the supernatural for the natural. It felt right. In some wonderful way, the privilege of motherhood had endowed my art with *heart*.

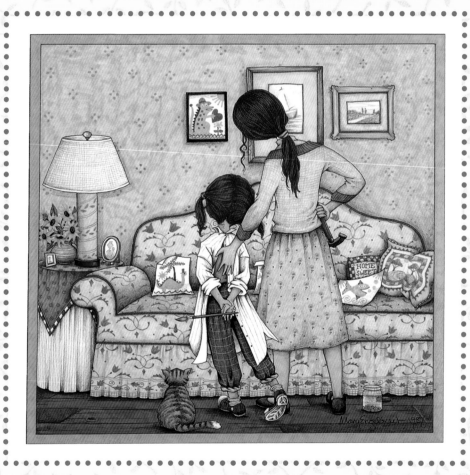

Becoming a mother also awoke cherished childhood memories of my own mother. Many of these memories have found their way into my art. My mom *really* did hang my paintings over the couch when I was a little girl as one of my drawings depicts. The diatribe spouted by the mother in my drawing titled "Dear Old Mom" is a direct quote from my mother—a pep talk she delivered countless times during my "formative" years.

I read a funny quote by the author Jean Kerr: "I'm never going to write my autobiography and it's all my mother's fault. I didn't hate her, so I have practically no material." I certainly agree with the sentiment. But for me, Motherhood—the nurturing, the caring, the laughter, the worrying, even the sheer exasperation— is a subject that I will never grow tired of depicting in my art.

So, in this book I've collected some of my favorite drawings on one of my favorite subjects— mothers. And along with my drawings, I've included favorite quotes about mothers from writers, poets, historical figures, and, of course, other mothers.

For all the mothers in the world, especially my own dear old mom . . . this one's for you, with love.

Mary

all good traits and learnings come
from the mother's side zora neale hurston

mother is not a person to lean on
but a person to make leaning unnec
essary doro... sometimes th
strength ... is greate
than natural laws barbara kingsolver th
heart of a mother is a deep abyss a
the bottom of which you will alway
discover forgiveness honoré de balzac we ar
together, my child and i, mother an
child, yes, but sisters really, agains
whatever denies us all that we ar
alice walker men are what their mother
made them ralph waldo emerson mother, giv

...from great writers

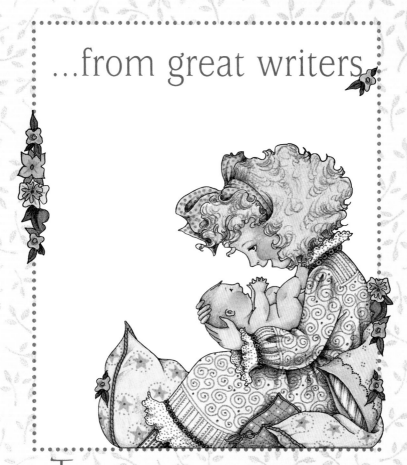

There is an amazed curiosity in every young mother.
It is strangely miraculous to see and to hold a living being
formed within oneself and issued forth from oneself.
–Simone de Beauvoir

for MOTHER O'MINE

If I were damned of body and soul,
I know whose prayers would make me whole,
Mother o' mine, o mother o' mine.

–Rudyard Kipling

I am all the time talking about you, and bragging,
to one person or another.
I am like the Ancient Mariner,
who had a tale in his heart he must unfold to all.
I am always buttonholing somebody and saying,
"Someday you must meet my mother."

–Edna St. Vincent Millay

A mother is not a person to lean on
but a person to make leaning unnecessary.

–Dorothy Canfield Fisher

And for the three magic gifts I needed
to escape the poverty of my hometown,
I thank my mother who gave me
a sewing machine, a typewriter,
and a suitcase.
–Alice Walker

BE STRONG

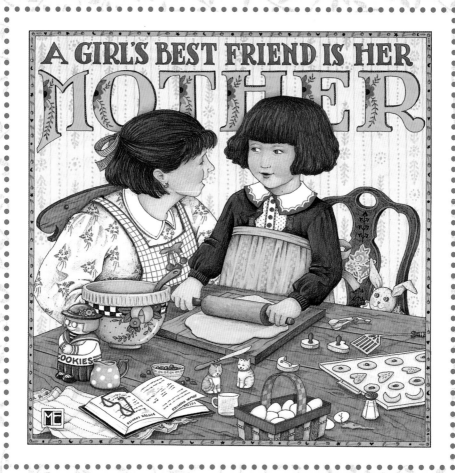

A GIRL'S BEST FRIEND IS HER MOTHER

We are together, my child and I, Mother and child, yes, but sisters really, against whatever denies us all that we are.
—Alice Walker

She broke the bread into two fragments
and gave them to the children,
who ate with avidity.
"She hath kept none for herself,"
grumbled the Sergeant.
"Because she is not hungry," said a soldier.
"Because she is a mother,"
said the Sergeant.

–Victor Hugo

Most mothers are
instinctive philosophers.

–Harriet Beecher Stowe

mary engelbreit

The heart of a mother is a deep abyss at
the bottom of which you will always
discover forgiveness.
—Honoré de Balzac

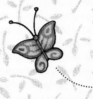

Mother is the name for God
in the lips and hearts of children.

—William Makepeace Thackeray

In the heavens above,
The angels, whispering to one another,
Can find, among their burning terms of love,
None so devotional as that of "Mother."

—Edgar Allan Poe

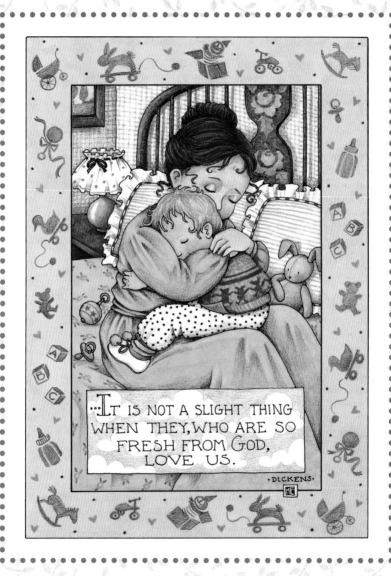

...It is not a slight thing when they, who are so fresh from God, love us.

·DICKENS·

THE BIG DAY

They always looked back
before turning the corner,
for their mother was always
at the window to nod and smile,
and wave her hand at them.
Somehow it seemed as if they
couldn't have got through the day
without that,
for whatever
their mood
might be, the
last glimpse of
that motherly face
was sure
to affect them
like sunshine.

—Louisa May Alcott

Men are what their mothers made them.
—Ralph Waldo Emerson

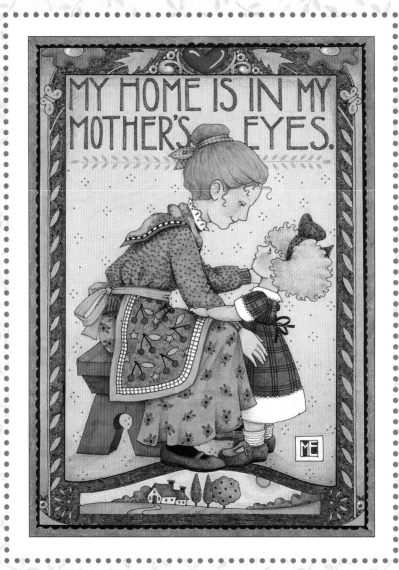

Your children are not your children.
They are the sons and daughters
of life's longing for itself.
They come through you but not from you,
and though they are with you,
yet they belong not to you.

–Kahil Gibran

Sometimes the strength of motherhood
is greater than natural laws.
–Barbara Kingsolver

All good traits and learnings
come from the mother's side.
–Zora Neale Hurston

Mother,
give me the sun.
—Henrik Ibsen

my mother is a woman who speaks with her life as much as with her tongue kesaya e. noda the source of human love is the mother african proverb there are times when parenthood seems nothing more than feeding the hand that bites you peter de vries my mother had a great deal of trouble with me but i think she enjoyed it mark twain a mother understands what a child does not say yiddish proverb if evolution really works, how come mothers still have only two hands? ed dussault thought my mom's whole purpose was to be my mom, that's how sh

...from the witty
and the wise

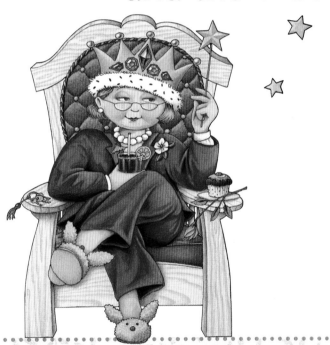

My mother is a woman who speaks with her life
as much as with her tongue.

– Kesaya E. Noda

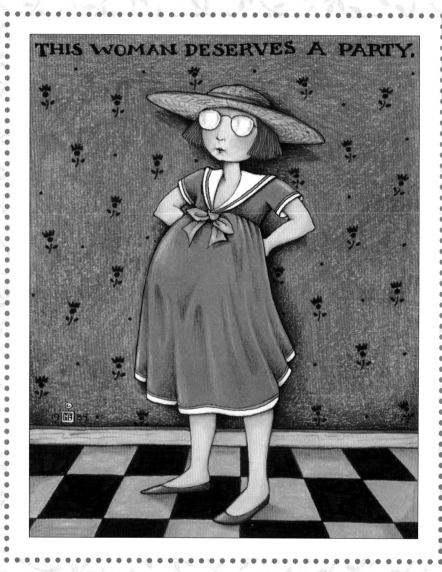

I never feel so good as when I'm pregnant.
It's the only time a woman can sit still,
do nothing at all,
and be beautifully productive.
—Maria Riva

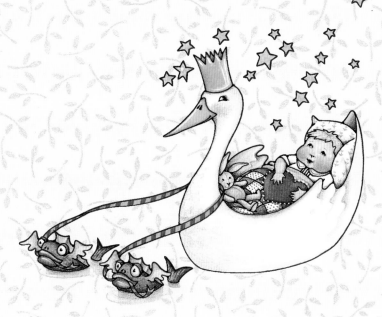

The only time a woman wishes she were a year older
is when she is expecting a baby.
— Mary Marsh

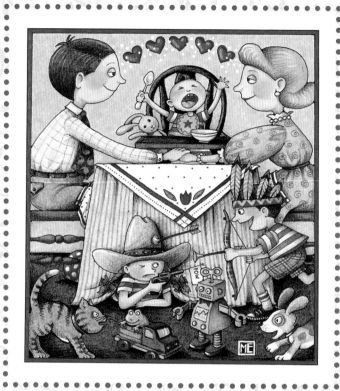

There are times when parenthood
seems nothing more than
feeding the hand that bites you.
—Peter De Vries

My mother had a great deal
of trouble with me,
but I think she enjoyed it.
—Mark Twain

When I was six I made my mother
a little hat—
out of her new blouse.

—Lilly Dache

To a mother, children are like ideas;
none are as wonderful as her own.
–Chinese saying

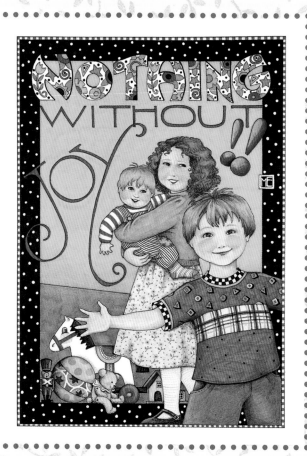

The source of
human love
is the mother.
–African
proverb

I thought my mom's whole purpose
was to be my mom.
That's how she made me feel.
–Natasha Gregson Wagner

A mother understands what a child does not say.
–Yiddish proverb

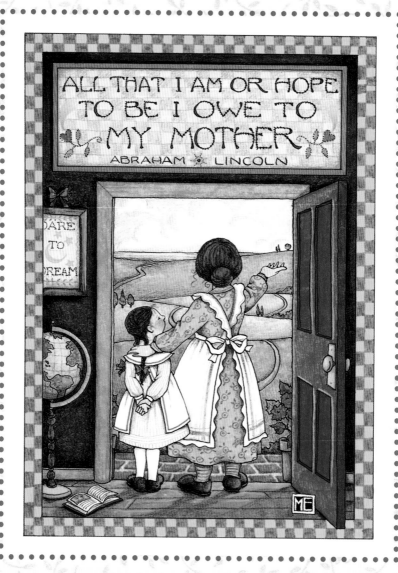

I think my life began with waking up
and loving mother's face.

~George Eliot

I wonder where mothers learn
all the things they tell their daughters
not to do.

~Eddie Cantor

If evolution really works,

how come mothers

still have only

two hands?

~Ed Dussault

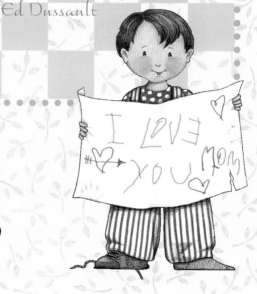

I think I'd be a good mother—
maybe a little overprotective.
Like I would never let the kid out—
of my body.
~Wendy Liebman

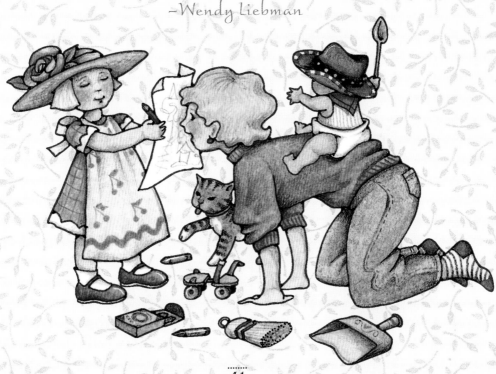

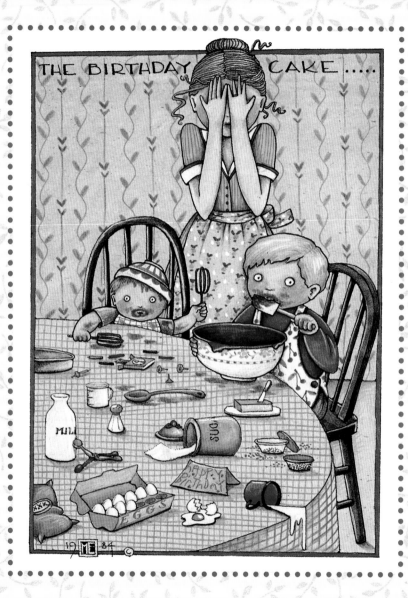

There is no other closeness
in human life
like the closeness between
a mother and her baby...
they are just a few heartbeats
away from being the same person.
—Susan Cheever

Part of the good part of being a parent
is a constant sense of déjà vu.
But some of what you have to vu
you never want to vu again.
—Anna Quindlen

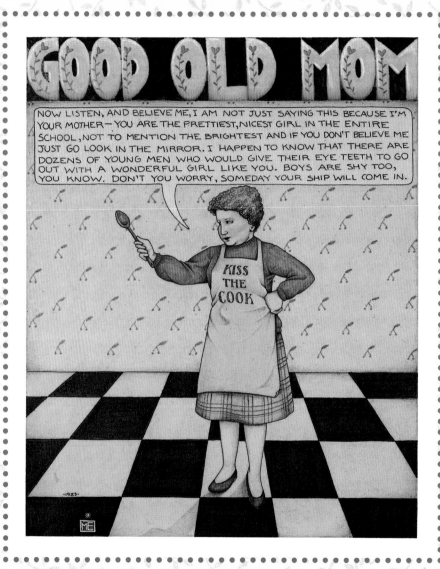

When a mother finally decides
to give her daughter some advice,
the mother usually learns plenty.
—Evan Esar

Mother Nature is providential.
She gives us twelve years
to develop love for our children
before turning them
into teenagers.
—William A. Galvin

The walks and talks
we have with our two-year-olds in red boots
have a great deal to do
with the values they will cherish as adults.
–Edith F. Hunter

Who takes the child by the hand
takes the mother by the heart.
–Danish proverb

oh what a power is motherhood
possessing a potent spell *euripides* son
are the anchors of a mother's lif
ophocles my mother's hands are coo
and fair, th hing. deli
cate mer there lik
flowers in *mpstead branch* a
is the mother, so is daughter
book of the prophet ezekiel, 1: 16 the precursor o
the mirror is the mother's face *d*
vinnicott women know the way to rea
up children. ... they know a simple
merry, tender knack of tying sashes
fitting baby-shoes, and stringin
pretty words that make no sense

...from the sages and the poets

Between the dark and daylight, When the night is beginning to lower,
Comes a pause in the day's occupations, That is known as the Children's Hour.
-Henry Wadsworth Longfellow

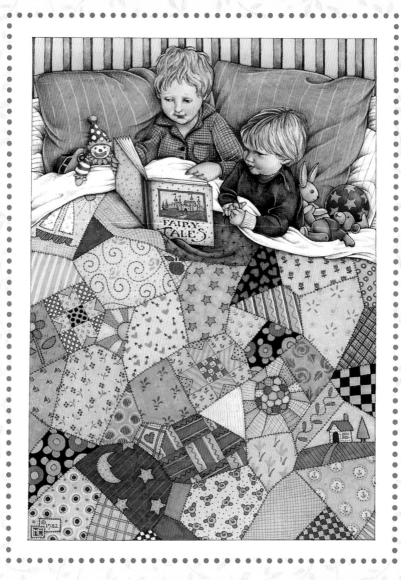

Don't aim to be an earthly Saint,
with eyes fixed on a star,
Just try to be the fellow
that your Mother
thinks you are.
–Will Sadkin

Sons are the anchors
of a mother's life.

–Sophocles

One race there is of men,
one of gods,
but from one mother
we both draw our breath.
–Pindar

Who ran to help me
 when I fell,
And would some
 pretty story tell,
Or kiss the place
 to make it well?

My mother.

–Ann Taylor, Jane Taylor

You too, my mother, read my rhymes
For love of unforgotten times,
And you may chance to hear once more
The little feet along the floor.
—Robert Louis Stevenson

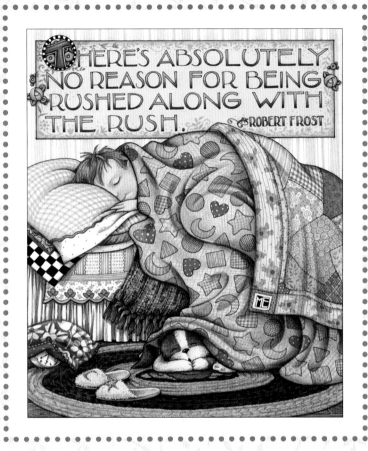

There's absolutely no reason for being rushed along with the rush. ~Robert Frost

There never was a child so lovely
 but his mother was glad to get him asleep.

–Ralph Waldo Emerson

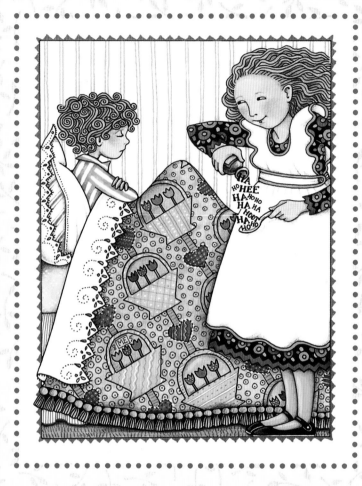

Oh what a power is motherhood,
possessing a potent spell.
~Euripides

Most of all the other
beautiful things in life
come by twos and threes,
by dozens and hundreds.
Plenty of roses, stars, sunsets,
rainbows, brothers and sisters,
aunts and cousins,
comrades and friends—
but only one mother in the whole world.

–Kate Douglas Wiggin

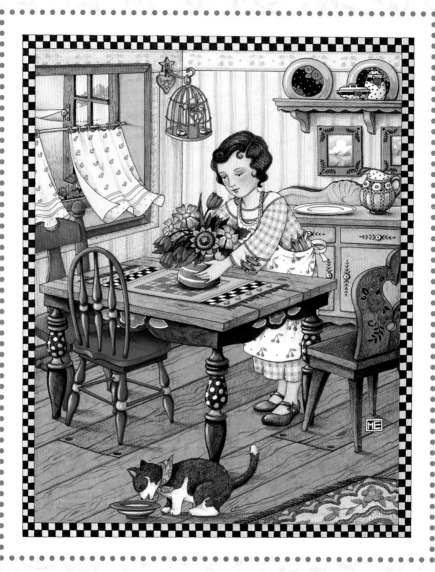

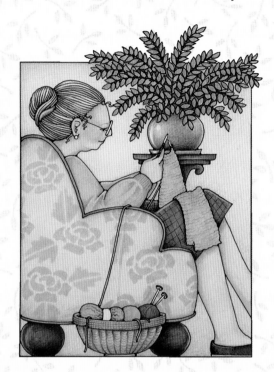

My mother's hands
are cool and fair.
They can do anything.
Delicate mercies
hide them there
Like flowers in the spring.
–Anna Hempstead Branch

Is not a young mother
one of the sweetest sights
life shows us?
—William Makepeace Thackeray

Guided by my heritage
of a love of beauty
and a respect for strength—
in search of my mother's garden,
I found my own.
—Alice Walker

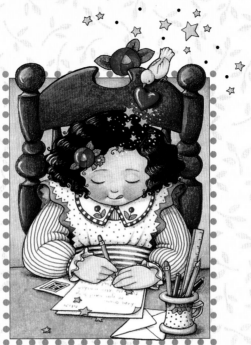

My mother is a poem
I'll never be able to write,
though everything I write
is a poem to my mother.

–Sharon Doubiago

As is the mother, so is her daughter.

–The Book of the Prophet Ezekiel, 1:16

61

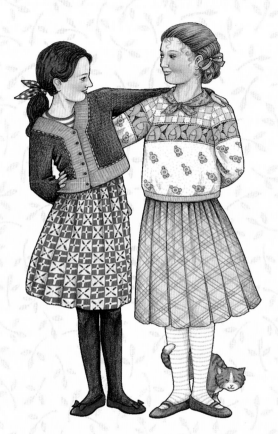

Let me not forget that I am the daughter of a woman …
who herself never ceased to flower, untiringly,
during three quarters of a century.

—Colette

Now that I am in my forties,
she tells me I'm beautiful ...
and we have the long, personal
and even remarkably honest phone calls
I always wanted so intensely
I forbade myself to imagine them. ...
With my poems,
I finally won even my mother.
The longest wooing of my life.

—Marge Piercy

youth fades; love droops; the leave of friendship fall; a mother's secre love outlives them all oliver wendell holm my mother was the most beautifu woman i ever saw all i am i ow to my mo we neve know the parents for u till we have become parents hanry war eecher all that i am or hope to be i ow to my angel mother. i remember m mother's prayers and they hav always followed me. they have clun to me all my life abraham lincoln the olde i become, the more i think about m mother i really learned

...from the famous and the familiar

My mother made a brilliant impression upon my childhood life.
She shone for me like the evening star—I loved her dearly.
-Winston Churchill

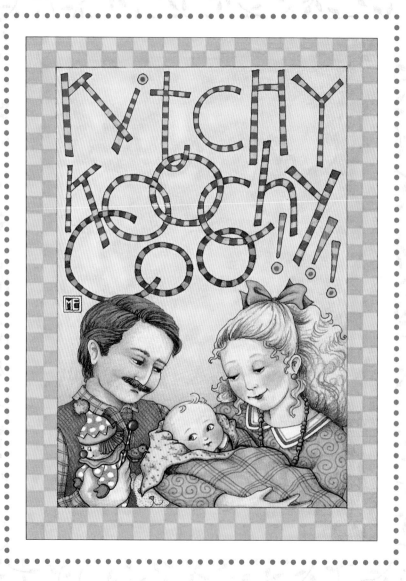

We never know the love of our parents for us
till we have become parents.
–Henry Ward Beecher

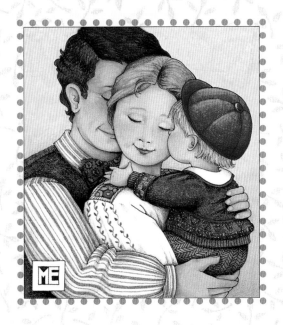

I really learned it all from mothers.
–Benjamin Spock

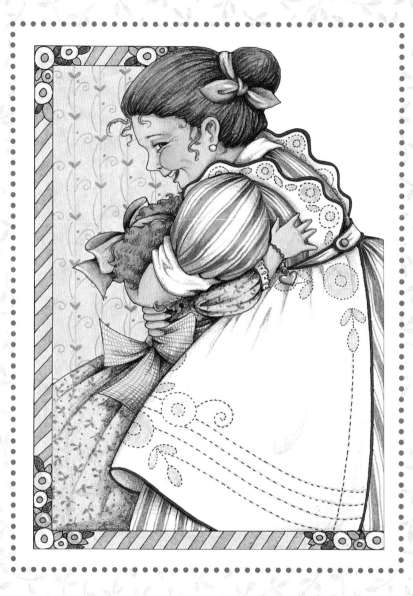

Youth fades; love droops;
 the leaves of friendship fall
A mother's secret love
 outlives them all.
 –Oliver Wendell Holmes

My mother had a slender, small body,
 but a large heart—
a heart so large that everybody's grief
and everybody's joy found welcome in it,
 and hospitable accommodation.
 –Mark Twain

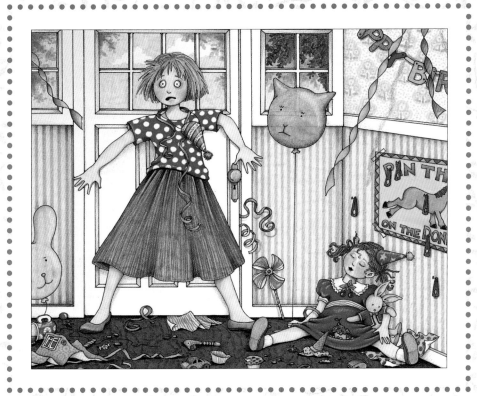

The precursor of the mirror is the mother's face.

–D.W. Winnicott

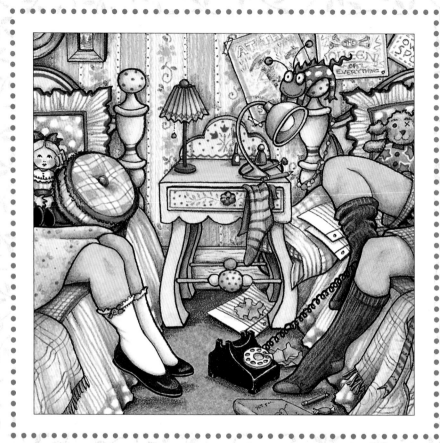

My sister said once:
 "Anything I don't want Mother to know,
I don't even think of, if she's in the room."
 –Agatha Christie

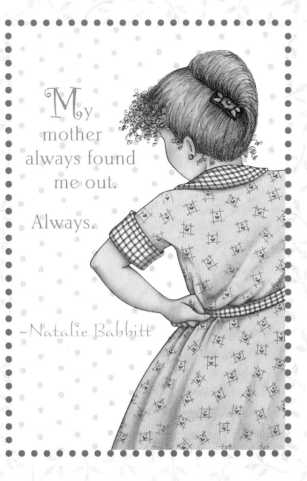

My
mother
always found
me out.

Always.

–Natalie Babbitt

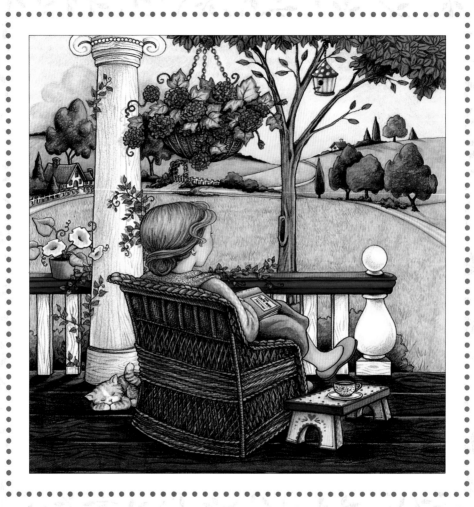

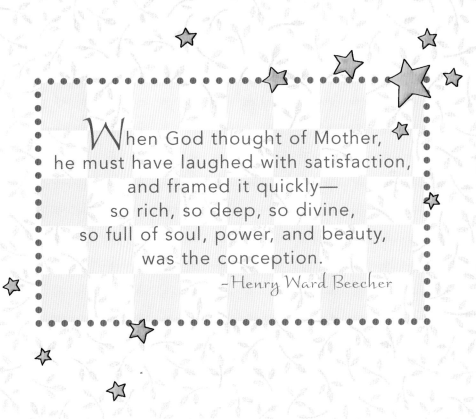

When God thought of Mother,
he must have laughed with satisfaction,
and framed it quickly—
so rich, so deep, so divine,
so full of soul, power, and beauty,
was the conception.
 –Henry Ward Beecher

God is a mother.
 –Eugene O'Neill

\mathcal{Y}ou give up your self,
and finally you don't even mind.
I wouldn't have missed this for anything.
It humbled my ego and stretched my soul.
It gave me whatever crumbs of wisdom
I possess today.

—Erica Jong

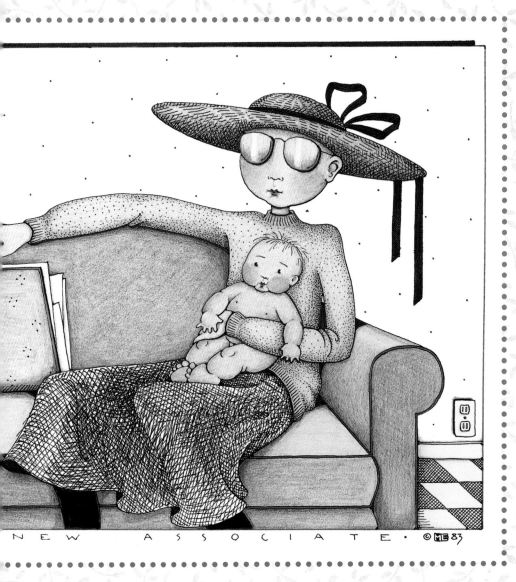

NEW ASSOCIATE · ©ME 83

All that I am or hope to be
 I owe to my angel mother.
I remember my mother's prayers
 and they have always followed me.
They have clung to me all my life.
 –Abraham Lincoln

it will be gone before you know it
the fingerprints on the wall appear
higher and higher. then suddenly
they disappear *dorothy evslin* a mother is
a person who seeing there are only
four pieces of pie for five people
promptly announces she never did
care for pie *tenneva jordan* who is getting
more pleasure from rocking, the
baby or me? *nancy thayer* it is not until
you become a mother that your
judgment slowly turns to compas
sion and understanding *erma bombeck* of
all the rights of women, the greates
is to be a mother ... like so man

...mother to mother

I looked at this tiny, perfect creature and it was as though a light switch
had been turned on. A great rush of love, flooded out of me.
-Madeleine L'Engle

In the sheltered simplicity of the first days
after a baby is born,
one sees again the magical closed circle,
the miraculous sense of two people
existing only for each other.
—Anne Morrow Lindbergh

Who is getting more pleasure from this rocking,
the baby or me?
—Nancy Thayer

A mother is a person who,
seeing there are only four pieces
of pie for five people,
promptly announces she never
did care for pie.
—Tenneva Jordan

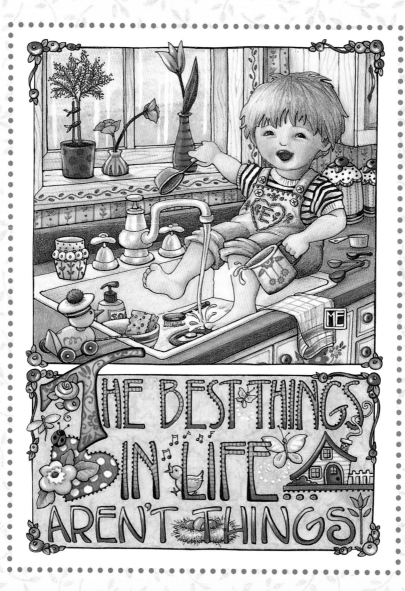

THE BEST THINGS IN LIFE AREN'T THINGS

It will be gone before you know it.
The fingerprints on the wall appear higher and higher.
Then suddenly they disappear.
— Dorothy Evslin

It is not until you become a mother
that your judgment slowly turns
to compassion and understanding.
— Erma Bombeck

There are so many disciplines
in being a parent besides the obvious ones
like getting up in the night and putting up
with the noise during the day.
And almost the hardest
of all is learning to be
a well of affection
and not a fountain,
to show them
we love them, not
when we feel like it,
but when they do.

-Nan Fairbrother

Before becoming a mother I had
a hundred theories on how to bring up children.
Now I have seven children and only one theory:
Love them, especially when
they least deserve to be loved.

~ Kate Samperi

Like so many things one did for children,
it was absurd but pleasing, and the pleasure came
from the anticipation of their pleasure.
–Mary Gordon

For the mother is and must be,
whether she knows it
or not,
the greatest, strongest,
and most lasting
teacher
her children have.
–Hannah Whitall Smith

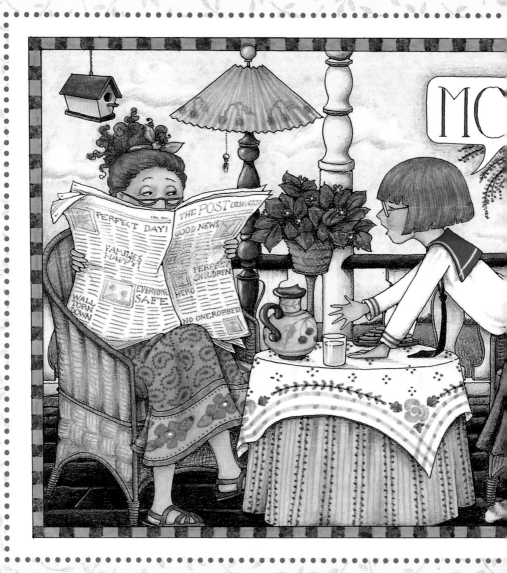

God knows a mother
needs fortitude and courage
and tolerance and flexibility
and patience and firmness
and nearly every other
brave aspect of the human soul.
But...I praise casualness.
It seems to me the rarest
of virtues.
It's useful enough when
children are small.
It is important to the point
of necessity when they
are adolescents.
–Phyllis McGinley

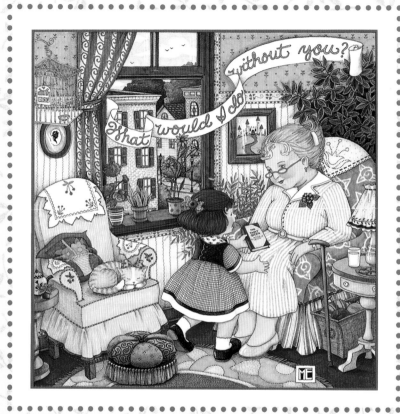

You can never really live anyone else's life,
not even your child's.
The influence you exert is through your own life,
and what you've become yourself.

-Eleanor Roosevelt

The older I become, the more I think about my mother.
—Ingmar Bergman

Of all the rights of women, the greatest is to be a mother.

—Lin Yutang

93

Making the decision to have a child—
it's momentous.
It is to decide forever
to have your heart go walking around
outside your body.
—Elizabeth Stone

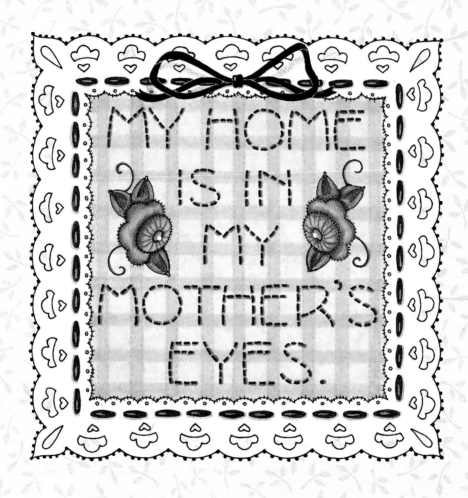

MY HOME IS IN MY MOTHER'S EYES.

is not a young mother one of the swee

all that i am or hope to be i owe to my m

is the mother *african proverb* a mother is not

leaning unnecessary *dorothy canfield fisher* oh w

potent spell *euripides* a mother understand

mothers are instinctive philosophers *ha*

come from the mother's side *zora neale hursto*

men are what their mothers made then

in the lips and hearts of children *william m*

parents for us till we have become par

from *t.s. eliot* none so devotional as tha

strength of motherhood is greater tha

my mother's eyes *unknown* there is an am

is strangely miraculous to see and to h

and issued forth from oneself